That's
How Much
I Love You

That's
How Much
I Love You

Drawings by Claudia Nizza
Words by Billy Mernit

Tallfellow Press
Los Angeles

Drawings and art concept by Claudia Nizza
Words and story concept by Billy Mernit
Cover and text design by Michael Serrian/Graphic Instincts

Published by
Tallfellow Press, Inc.
1180 South Beverly Drive, Suite 320
Los Angeles. CA 90035

Distributed to the trade by
Andrews McMeel Distribution Services
4520 Main Street
Kansas City, Missouri 64111

ISBN 0-9676061-0-1

Printed in the USA by Command Web Offset Company
10 9 8 7 6 5 4 3 2 1

Tallfellow Press
Los Angeles

Author's Note

After Claudia returned to Rome from Los Angeles, I called her one night and asked, half-kiddingly, "Have I told you lately that I love you?" And she said, "No." So I said, "Oh! Well, say you're swimming to the bottom of the deepest ocean...but it's so deep that you're already in another lifetime when you find out you haven't even swum through the first layer of it... You know how big that ocean is? That's how much I love you." And she liked this.

It became a game between us. Every time I called, I'd ask and she'd say "No," and I'd make up these little stories, until one time I called and she said:

"Okay, we do a book."

--Billy Mernit

Dedicated to

Dick and DeeAnn Mernit
and
Remo and Fedora Nizza

Artist's Note

This little book was completed in less than two months in my studio in Venice, California. Billy Mernit's stories, with their rhythmic energy and the direct communication of hip-hop songs, brought me into a world of freedom and creativity.

As a painter who creates work by observing the bodies of dancers in motion, I found it a fascinating experience to use only my imagination to show the emotions of words like an "unhappy oyster" or "all the kisses I've ever received."

The power of love is the primary engine that Billy and I have used to shape in words and colors the secret poetry hidden within everybody's heart.

--Claudia Nizza

Have I told you lately that I love you?

No.

Okay, then...

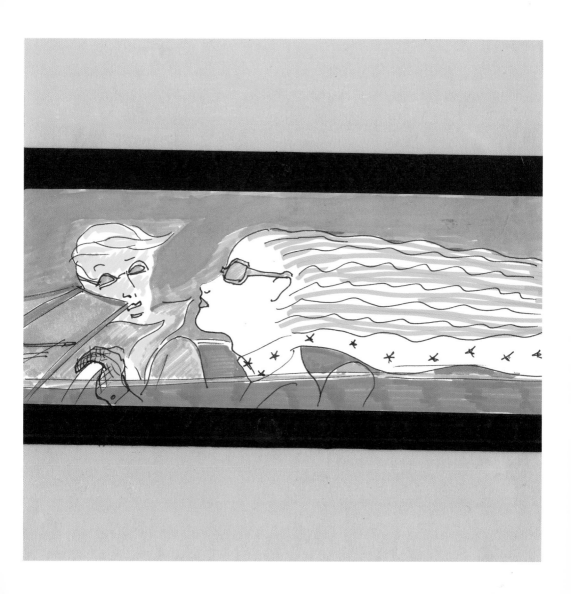

Think of all the women who are waking

on all the pillows of the world

and imagine the strands of hair

those many women are leaving there...

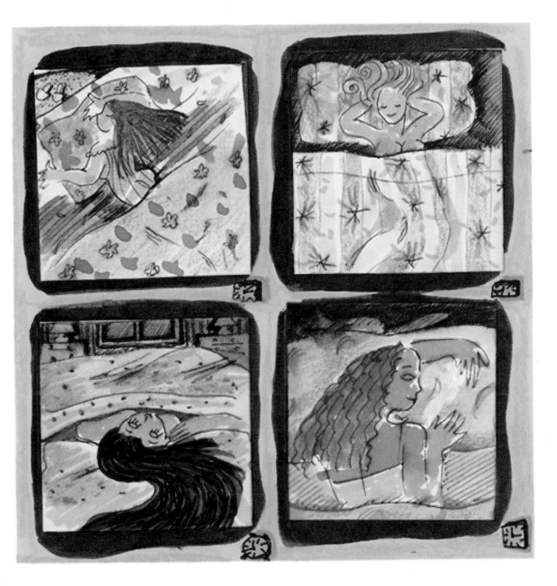

If you were to weave them all together

you'd have a necklace

long enough to wind around the earth.

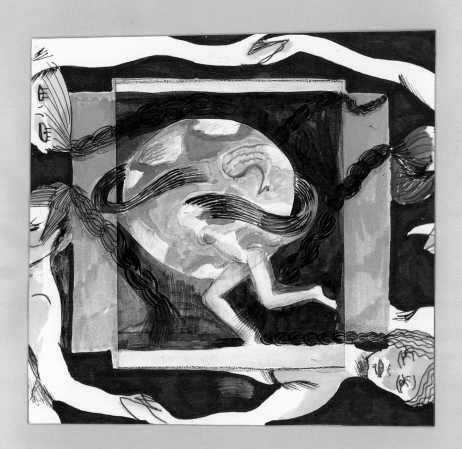

Do you know how fine and long

that necklace would be?

Tell me.

That's how much I love you.

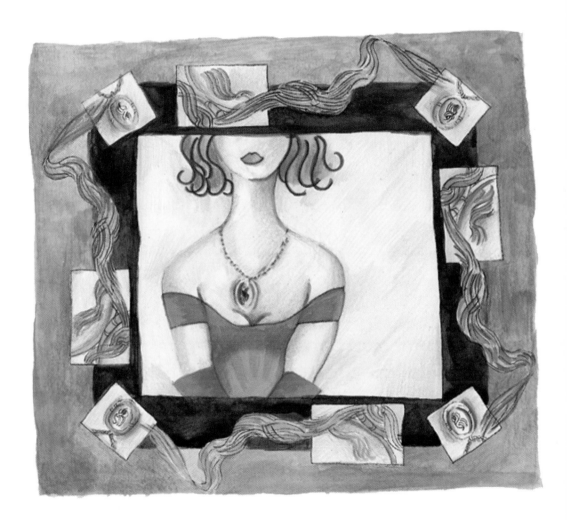

Have I told you lately that I love you?

I don't think so.

Well...

Remember your first kiss?

Remember the other kisses it led to?

Think of all the kisses you ever received...

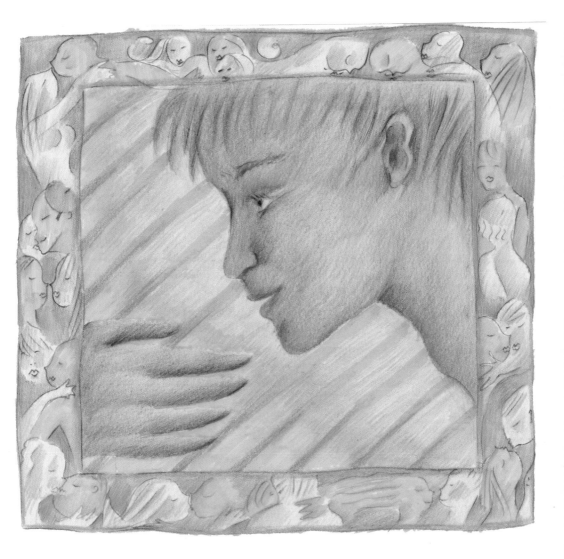

on your lips and your cheeks

and your neck and your shoulders

and every place on your body

from the top of your head

to the tip of your small toe...

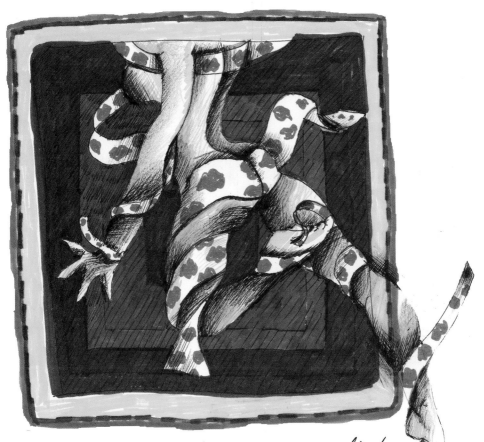

to the tip of your small toe

Plus the sum of all the kisses

you've ever given

to every other living thing

from grandmothers to cats to canaries--

Imagine the feeling

the sum total of those kisses

would give you...

I've got goose bumps.

That's how much I love you.

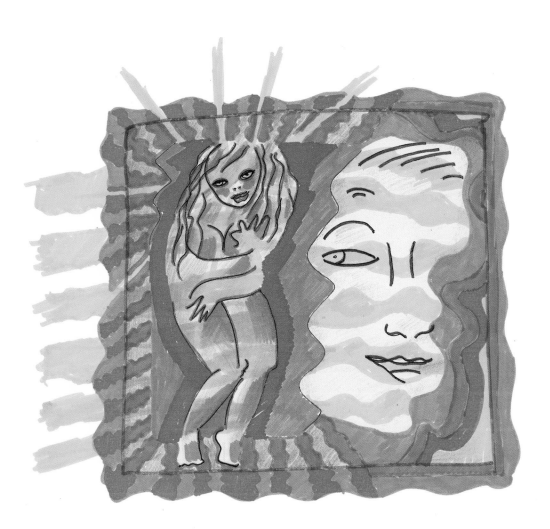

Have I told you lately... ?

Not really.

Then imagine yourself deep

in the most secret center

of the deepest jungle in the Amazon

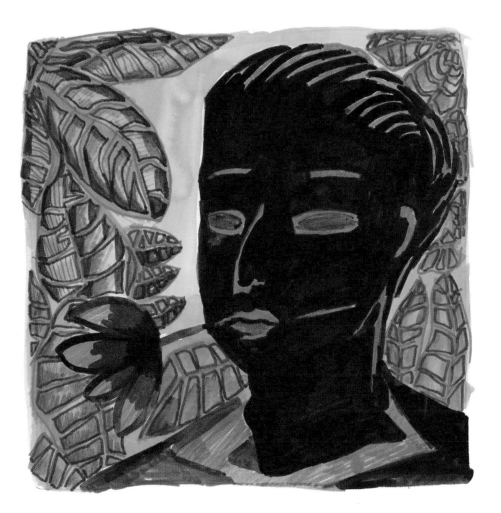

where in a cave behind a waterfall

when the moon is full,

on the one extra night

that comes every leap year,

a single flower blooms...

and by morning it's gone.

It's such a rare flower

that it doesn't have a name--

no human's ever seen it.

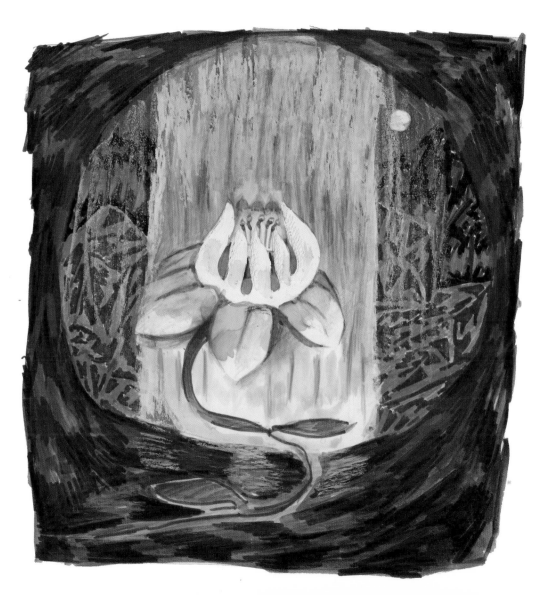

But there's a tropical hummingbird

that spends its life

flying in search of this moon-blossom,

and the ones who have tasted of its nectar

never drink from another flower again.

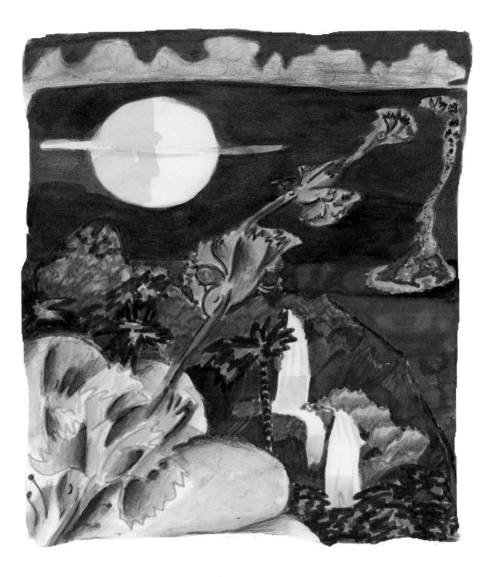

Can you imagine how sweet

this flower's scent must be?

Mmmm...

That's how much I love you.

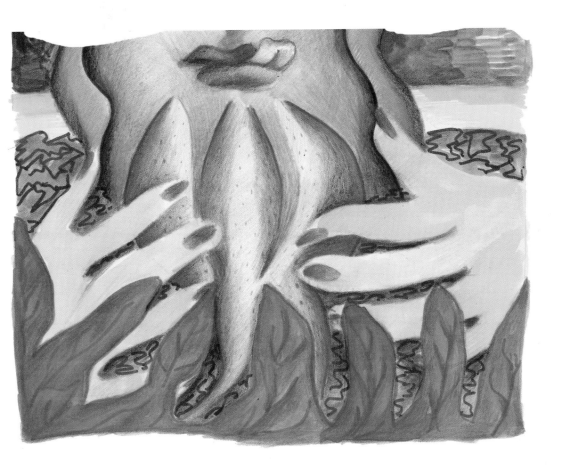

Have I--

No, you haven't.

Well... Picture a blue grotto

at the bottom of the deepest sea

and an oyster living there who's very sad.

All his brothers, sisters, uncles, aunts and cousins

have big beautiful pearls inside them

and this oyster does not.

So to fill up his emptiness

this oyster goes traveling the ocean floor

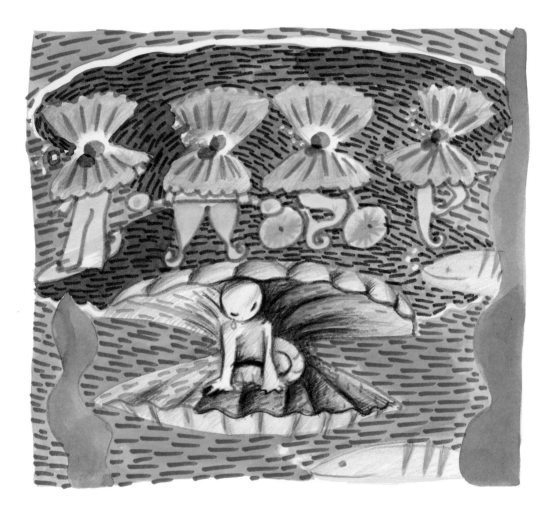

befriending anyone he meets

who seems to be in need:

a starfish who's missing a point,

a crippled calamari, a sting-less ray...

The oyster provides for all,

a wandering St. Francis of shellfish.

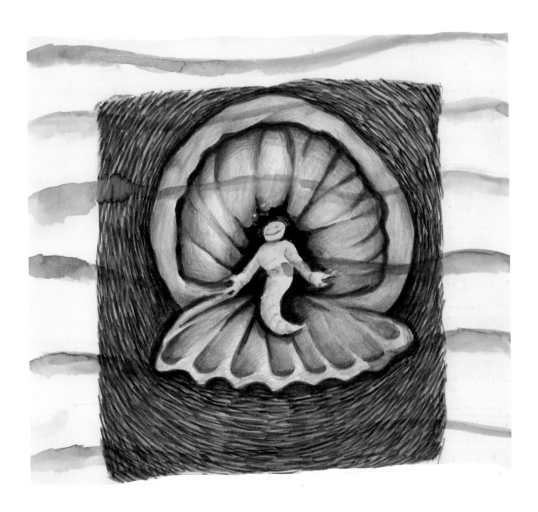

And when he dies and is returned

to the grotto of his brothers and cousins,

they find the tiniest, hair-thin slip of a baby pearl

glimmering in the darkness at the center of his shell.

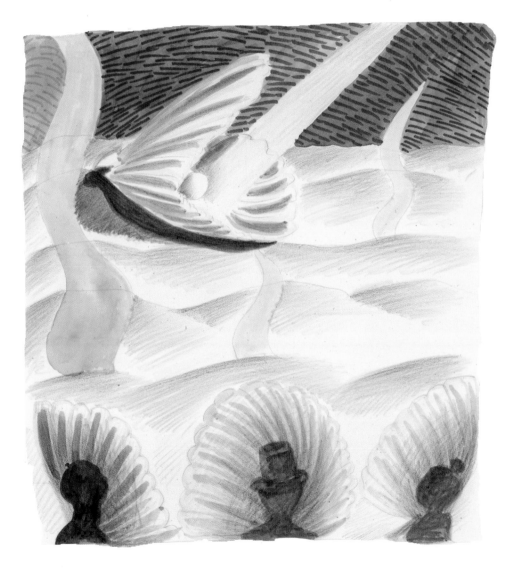

Do you have any idea how much that pearl is worth?

I can imagine...

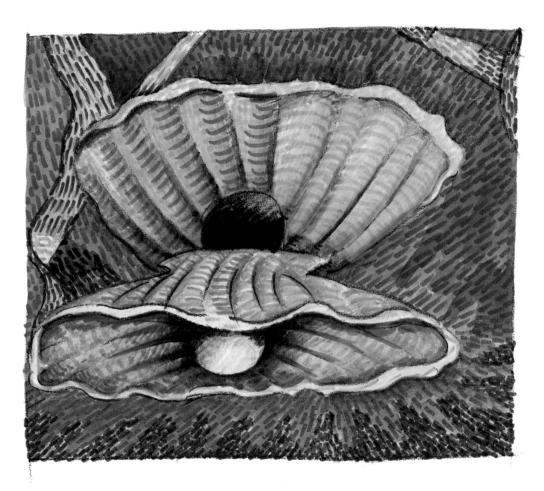

That's how much I love you.

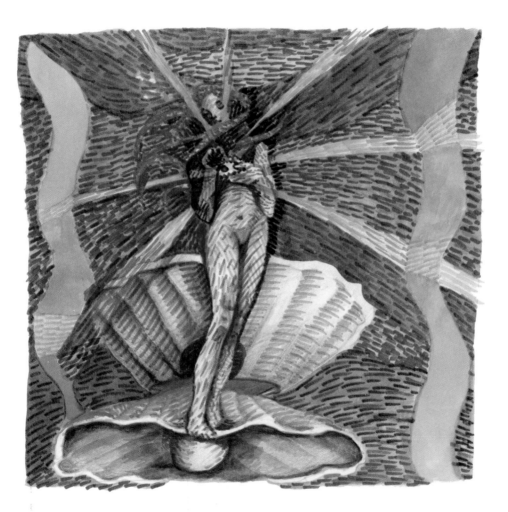

Haven't I told you lately...?

I'd remember.

Then think of the sun.

The sun?

Can you look at it?

No.

And why is that?

It's too bright.

How bright is it?

Who knows?

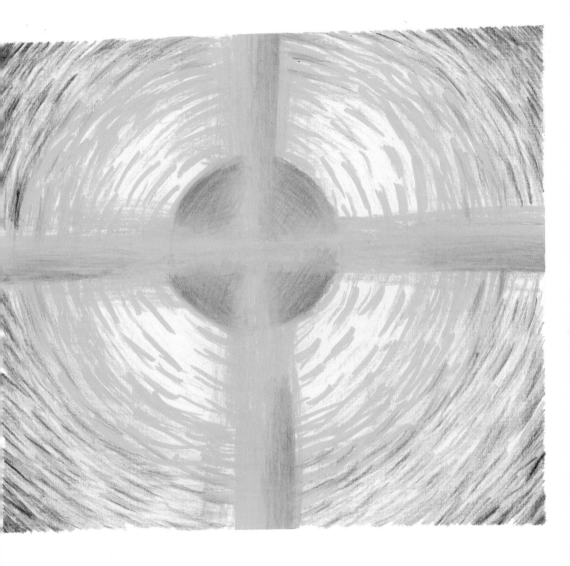

Well, that's how much I love you.

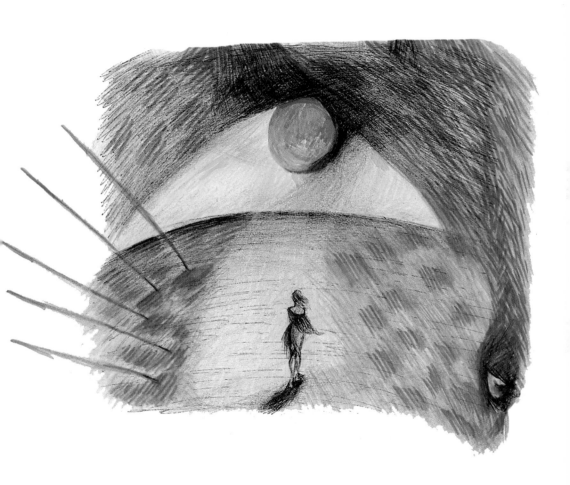

Have I told you...?

I'm listening.

Far to the north

in a country where it's always winter

and there's nothing but white as far as the eye can see,

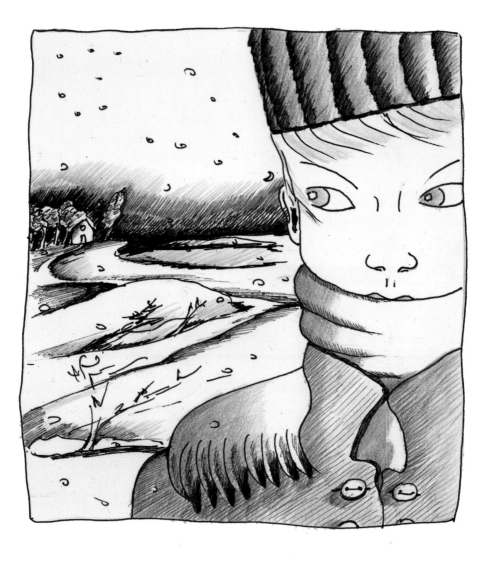

an old woman lives in a cabin

at the edge of a wood,

where at night if you step outside you turn to ice.

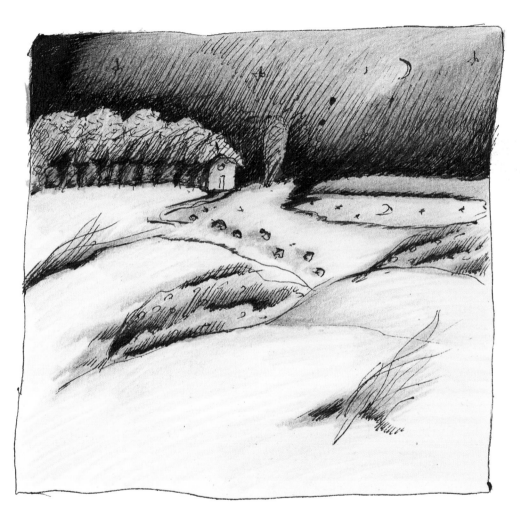

And in the darkest dead

of the longest white winter night,

when she's out of firewood,

she unwraps a single coal from inside the stove--

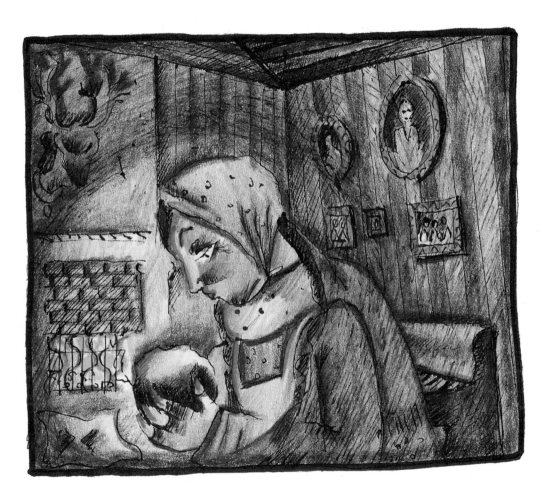

a coal given to her by her mother

who got it from her mother

and a line of great-great-ancestors.

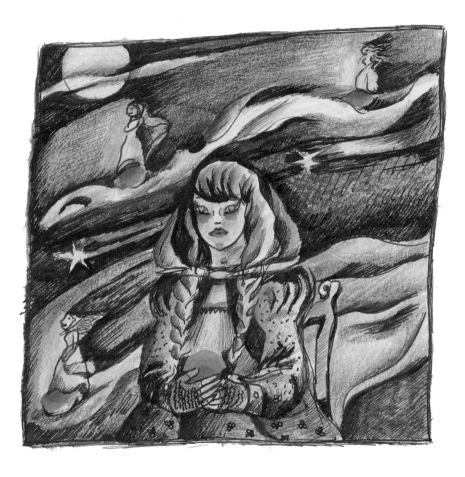

The woman places this treasure in the fireplace

and pulls a chair up beside,

and so long as she blows on the coal,

it keeps her alive on the longest winter night.

Can you imagine the color of that single coal

as she leans in to blow and it glows?

So red!

That's how much I love you.

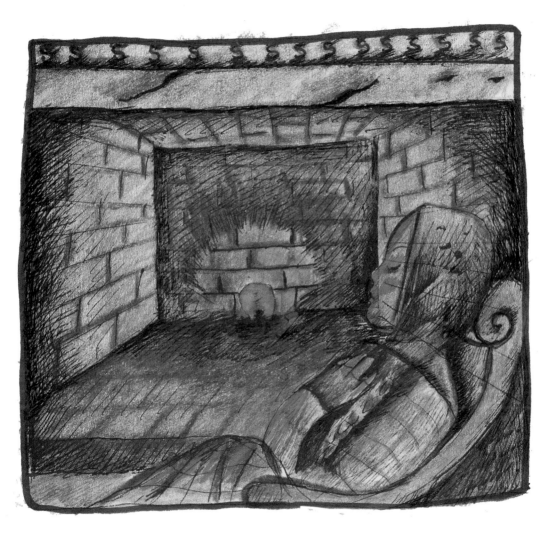

Hey --

Remember that windy night right before Halloween
when the gardener was coming
and you wanted me to rescue the spider
who built a new home every day
over the dandelion bush by our front steps...
Despite my fear and loathing of spiders
I coaxed it from web to leaf
and into a box which I carried
to the park across the street
and emptied, extra carefully,
so your Spidey could have a happy Halloween--?

You were very brave.

That's how much I love you.

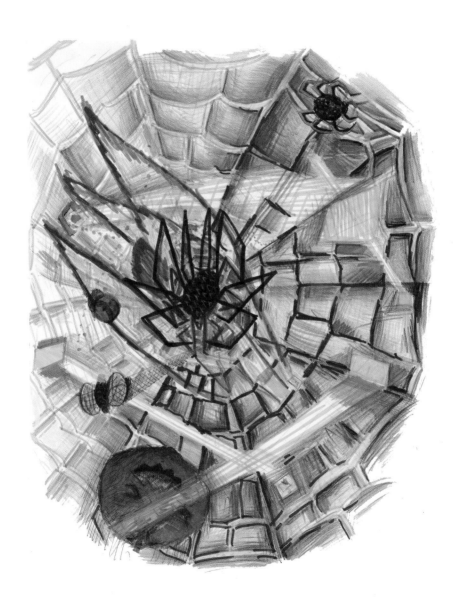

You know how much, don't you?

Not exactly.

If you asked me to,

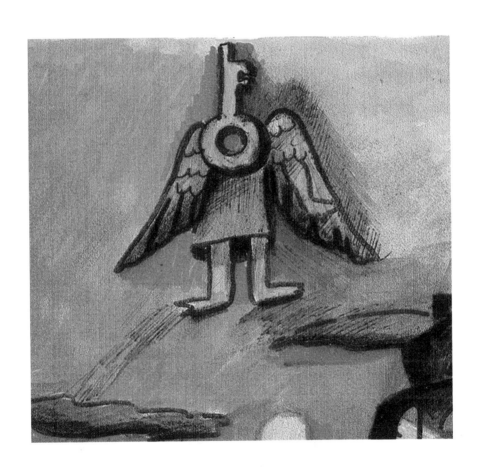

I would climb all the steps

that lead to all the churches

and plazas and ruins of Rome

including the 330 steps of St. Peter's

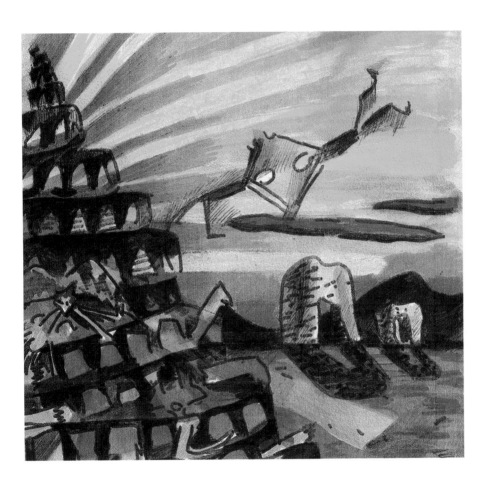

...until I stood on the top

and bumped my head

on the feet of an angel.

Now that's high.

That's how much I love you.

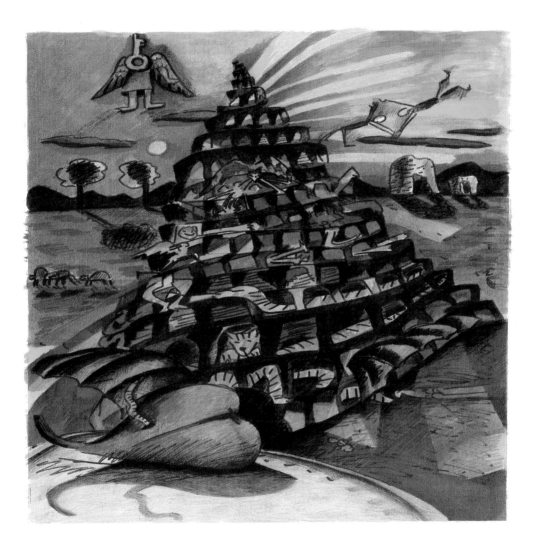

Have I told you lately that I love you?

Tell me one more time.

Alright. So...

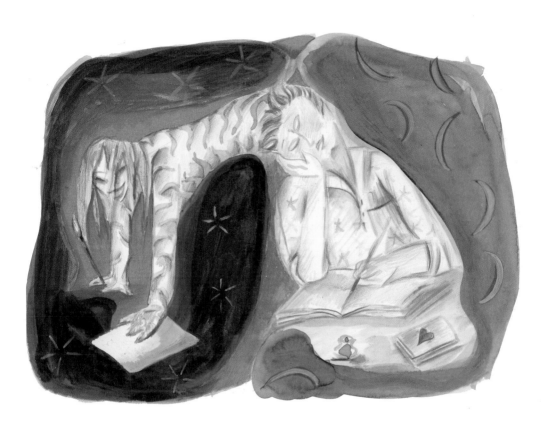

How many notes can a nightingale sing?

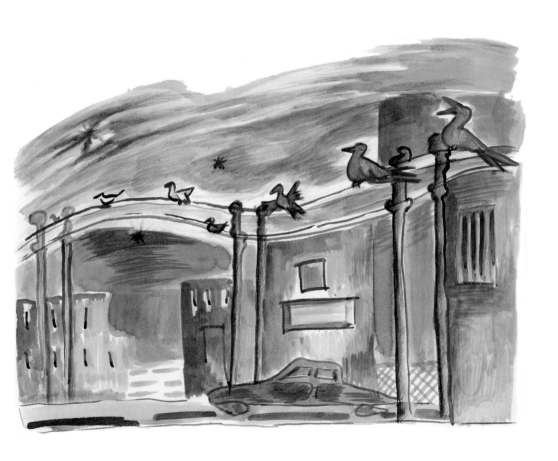

How many sake bottles in Japan?

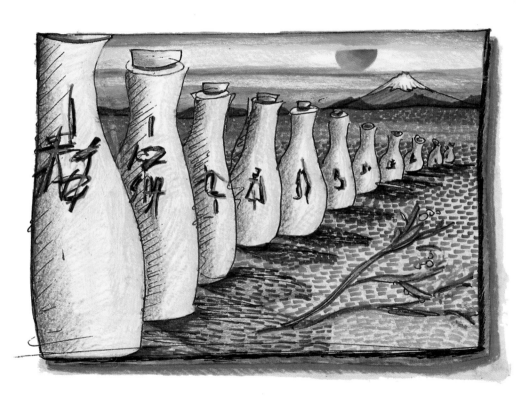

Count up every blossom that's ever bloomed.

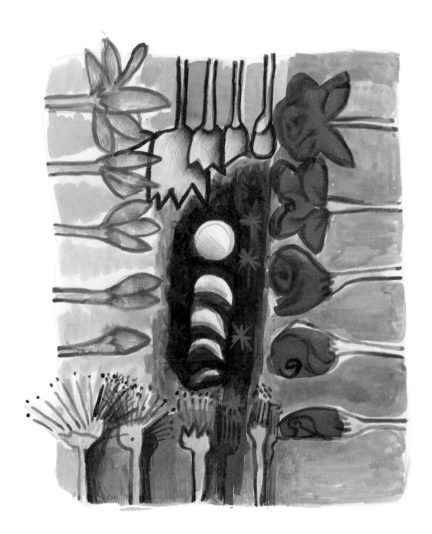

All the sunsets since the dawn of man.

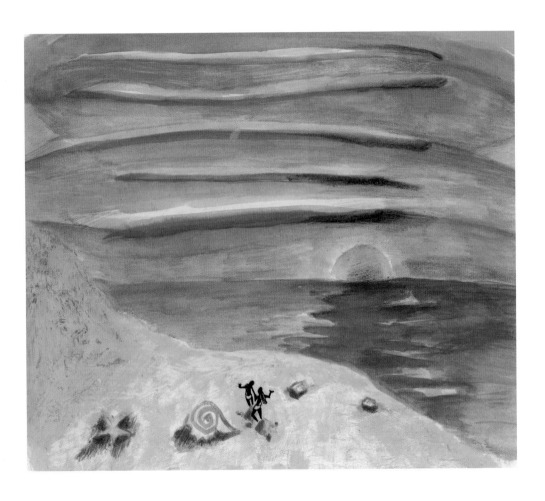

How high is the highest that a Dalai Lama gets?

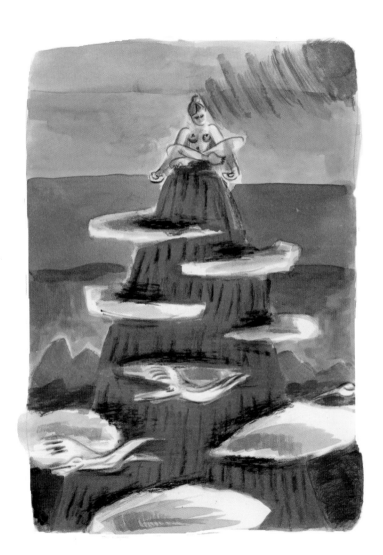

How low is the lowest of the low?

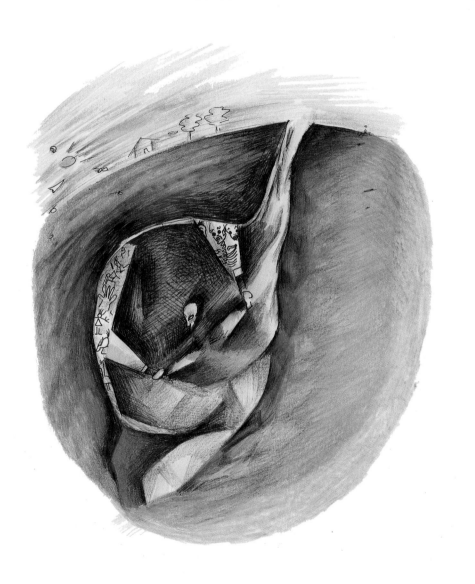

What's the total sum of everybody's debts?

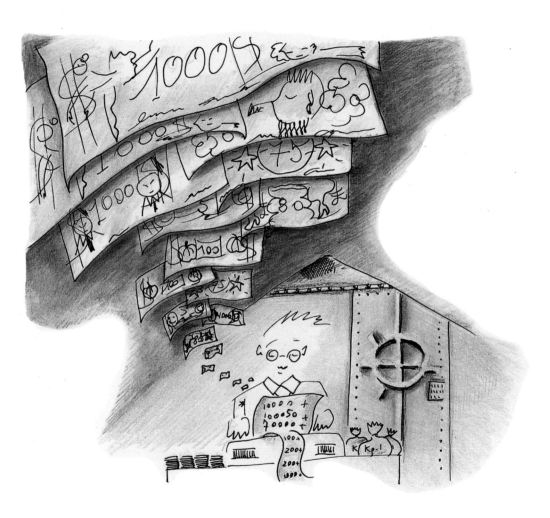

The wattage of the North Star's glow?

Think of a blue--No, bluer than that--

the bluer-than-the-bluest blue.

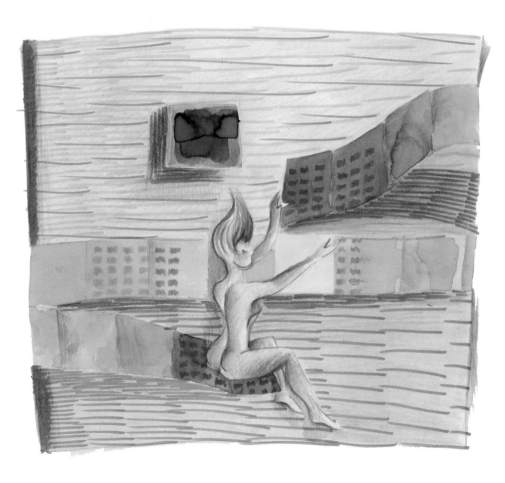

Think hotter than the hottest cat can blow.

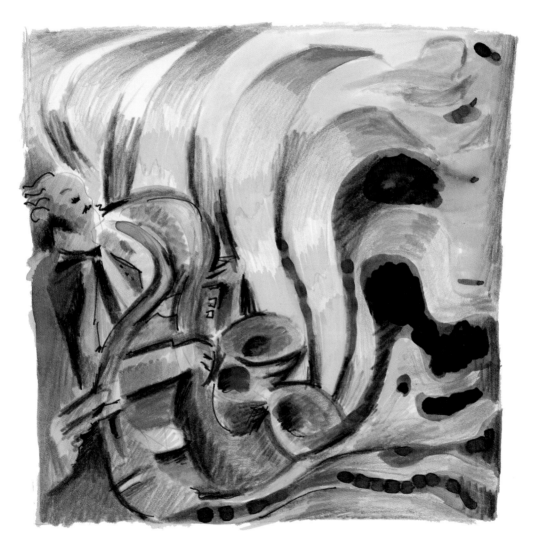

The blackest black a bean can brew.

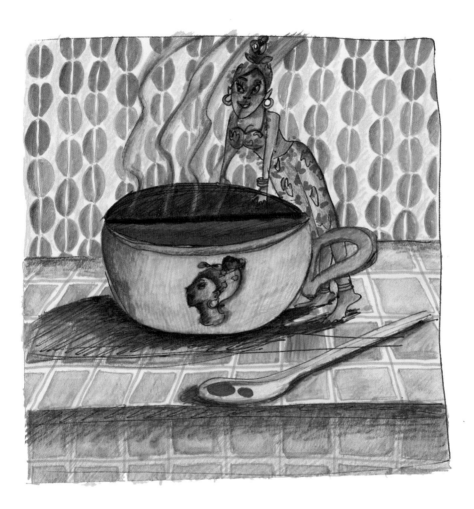

How many breaths have you taken since your birth?

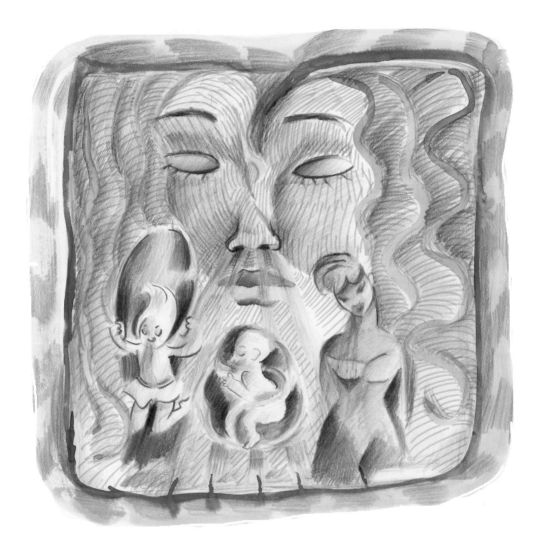

How many apples have ever been pied?

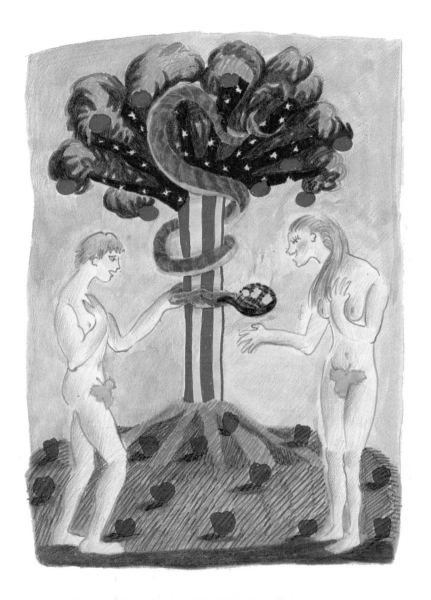

How strong is the pull between

full moon and tide?

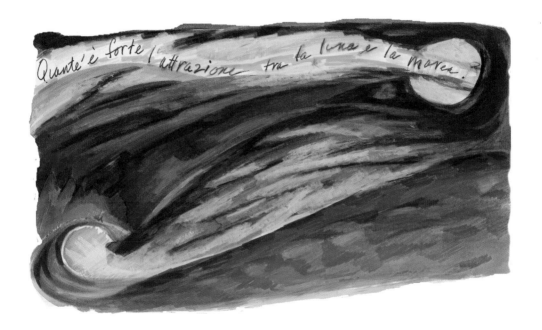

Quante'è forte l'attrazione tra la luna e la marea.

That's how much?

That's how much I love you.

to Mr. Bill Mernit
914 # Electric Ave
Venice CA: 9029
U.S.A.

CLAUDIA NIZZA was born in Rome. Her work as a painter and designer has included projects for internationally renowned choreographers Lindsay Kemp and David Parsons. Her book of drawings, "Sogno" (1997), and bookmarks collection, "Il colore della danza" (1999), are published by Postcart s.r.l. Italy. Her paintings are being shown throughout Italy and the United States.

BILLY MERNIT has written in many mediums, from songwriting (for Judy Collins and Carly Simon) to non-fiction ("Writing the Romantic Comedy" Harper-Collins). An expatriate New Yorker, he lives in Venice, California and teaches at UCLA Extension.

Claudia and Billy met in the Hollywood Hills during a moonlight hike and were married exactly one year later on a hilltop above Malibu.

(Authors' photo by Fergus Greer)